DRAW 50

Endangered Animals

The Step-by-Step Way to Draw Humpback Whales, Giant Pandas, Gorillas, and More Friends We May Lose . . .

BOOKS IN THIS SERIES

- *Draw 50 Airplanes, Aircraft, and Spacecraft*
- *Draw 50 Aliens*
- *Draw 50 Animal 'Toons*
- *Draw 50 Animals*
- *Draw 50 Athletes*
- *Draw 50 Baby Animals*
- *Draw 50 Beasties*
- *Draw 50 Birds*
- *Draw 50 Boats, Ships, Trucks, and Trains*
- *Draw 50 Buildings and Other Structures*
- *Draw 50 Cars, Trucks, and Motorcycles*
- *Draw 50 Cats*
- *Draw 50 Creepy Crawlies*
- *Draw 50 Dinosaurs and Other Prehistoric Animals*
- *Draw 50 Dogs*
- *Draw 50 Endangered Animals*
- *Draw 50 Famous Cartoons*
- *Draw 50 Flowers, Trees, and Other Plants*
- *Draw 50 Horses*
- *Draw 50 Magical Creatures*
- *Draw 50 Monsters*
- *Draw 50 People*
- *Draw 50 Princesses*
- *Draw 50 Sharks, Whales, and Other Sea Creatures*
- *Draw 50 Vehicles*
- *Draw the Draw 50 Way*

DRAW 50

Endangered Animals

*The Step-by-Step Way to Draw Humpback
Whales, Giant Pandas, Gorillas, and
More Friends We May Lose . . .*

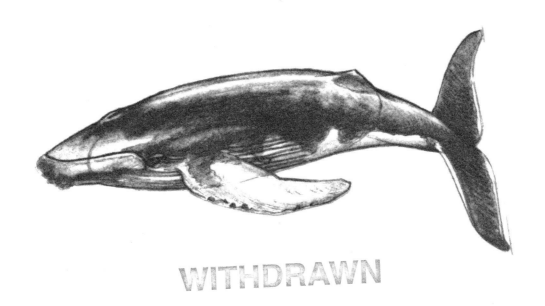

LEE J. AMES
with Warren Budd

Watson-Guptill Publications, New York

Published in the United States by Watson-Guptill Publications,
an imprint of the Crown Publishing Group, a division of Random
House, Inc., New York, in 2013.

www.crownpublishing.com
www.watsonguptill.com

WATSON-GUPTILL and the WG and Horse designs are
registered trademarks of Random House, Inc.

Originally published in hardcover in the United States by
Doubleday, a division of Random House Inc., New York, in 1992.

Library of Congress Cataloging-in-Publication Data

Ames, Lee J.
Draw 50 endangered animals / Lee J. Ames with Warren Budd.
 p. cm.
1. Animals in art. 2. Endangered species in art. 3. Drawing—Tech-
nique. I. Budd, Warren. II. Title. III. Title: Draw fifty endangered
animals.
 NC780.A4 1993
743'.6—dc20 93-25334
 CIP

ISBN 978-0-8230-8608-5
eISBN 978-0-8230-8609-2

Printed in the United States of America

10 9 8 7 6 5 4 3 2 1

This book is dedicated,
with deep concern, to us all.
For we, too, are endangered.

To the Reader

To be able to see, and for the most part, to have enjoyed what I've been able to see, has filled my life with constant pleasure. Being able to reproduce, by drawing, what I see, or what I visualize in my imagination, adds even more satisfaction. Being able to show others, like yourselves, how to construct a drawing, tops it all.

In this world of glorious things to see, some may not be with us for long. Among these are many wonderful living creatures. These are the endangered animals with whom, as long as we've existed, we've shared this earth. Let's learn to draw these friends before they may leave us forever.

Warren Budd, whom I've known and worked with for many years, did a lion's share of the research and the art for this book. I've watched him develop from a raw, insecure art school student to the accomplished artist with whom I'm delighted to share coauthorship.

When you start working I suggest you use clean white bond paper or drawing paper and a pencil with moderately soft lead (HB or No. 2). Keep a kneaded eraser handy (available at art supply stores). Choose the subject you want to draw and then, very lightly and very carefully, sketch out the first step. Also very lightly and carefully, add the second step. As you go along, study not only the lines but the spaces between the lines. Size your first steps to fill your drawing paper agreeably, not too large, not too small. Remember, the first steps must be constructed with the greatest care. A mistake here could ruin the whole thing.

As you work it's a good idea, from time to time, to hold a mirror to your sketch. The image in the mirror frequently shows distortion you may not recognize otherwise.

You will notice that new-step additions (in color) are printed darker. This is so they can be clearly seen. But remember to always keep your construction steps very light. Here's where the kneaded eraser can be useful. You can lighten a pencil stroke that is too dark by pressing on it with the eraser.

When you've softly sketched all the light steps, and you're sure you have everything the way you want it, finish your drawing with firm, strong penciling.

If you like, you can go over your drawing with India Ink (applied with a fine brush or pen), or a permanent fine-tipped ballpoint or felt-tipped marker. When thoroughly dry, you can then use the kneaded eraser to clean off all the underlying pencil marks.

Remember, if your first attempts at drawing do not turn out the way you'd like, it's important to keep trying. Your efforts will eventually pay off and you'll be pleased and surprised at what you can accomplish. I sincerely hope you'll improve your drawing skills and have a great time recording drawings of our endangered friends.

An Additional Note

As a preteen student in New York City's public school system, I did well enough. During the drawing periods, however, I had an edge. Drawing classes were relaxed and, for the most part, easy fun. There, I was better than average. There, I was able to do what I most loved. The approval I received encouraged me to avidly pursue further drawing skills. In addition, that pleasant time carried over and enhanced my entire school experience. Then, while I was in the sixth grade, in the middle of the school term my family moved to another borough of the city. I was enrolled in a new school.

A difficult time followed. Some of the courses were entirely different; the new way of teaching familiar subjects had me totally confused. It all seemed so overwhelming, what with new kids, no friends, and a great deal of homework to catch up on.

There was, however, something to look forward to . . . a drawing period on Friday afternoon! Now, I would have a chance to display what I could do best. Now, I might receive friendly, favorable recognition.

Finally Friday came. But just as the drawing period was about to begin, the teacher brought another student's history notebook to my desk. "Here," she said, "you can spend this time copying Robert's notes into your notebook. Drawing is not that important."

Three unpleasant weeks followed. Then I had an incredible stroke of luck! My parents were notified that I'd been placed in the wrong school district. I was transferred to another school, Public School 12 in the borough of Queens. At P.S. 12, drawing class *was* considered important. There, I began to experience wonderful things.

Not only did this school regard the drawing class as important, but the teacher understood the significant value of encouraging each and every student.

We were permitted to invent, to explore, to copy. Being allowed to "copy" was unusual then. That teacher, I feel, was way ahead of her time. Copying permitted me to explore many different kinds of drawings and ways to draw. It also helped me develop the necessary drawing muscles enabling me to hone my skills.

Mimicry and copying, I find, are prerequisites to creativity!

It is my hope that you will be able to come up with drawings that will bring gratifying approval from friends and family. After that I look forward to the competition.

LEE J. AMES

DRAW 50
ENDANGERED
ANIMALS

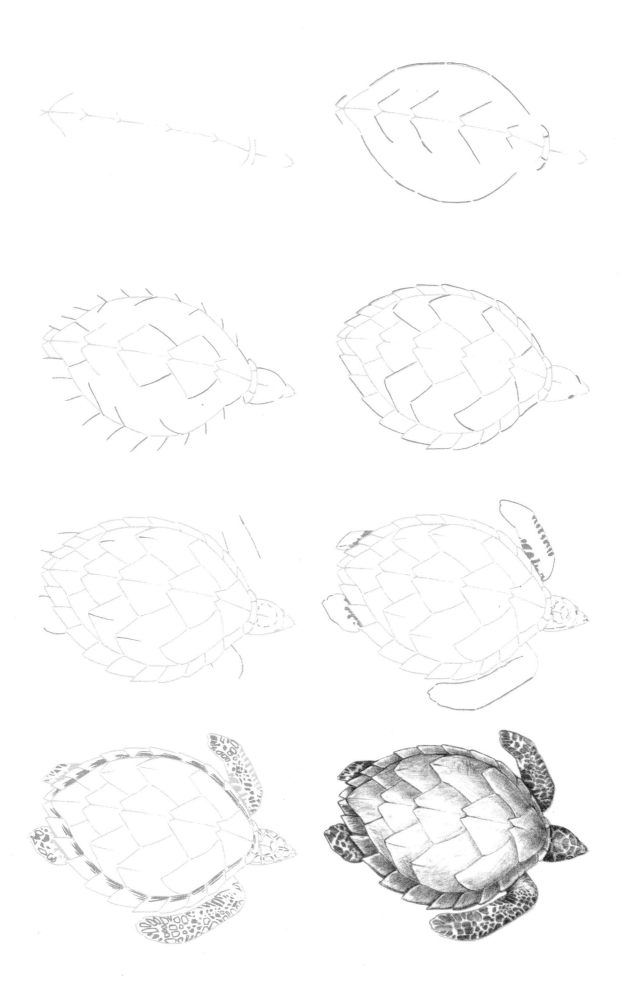

Hawksbill Turtle

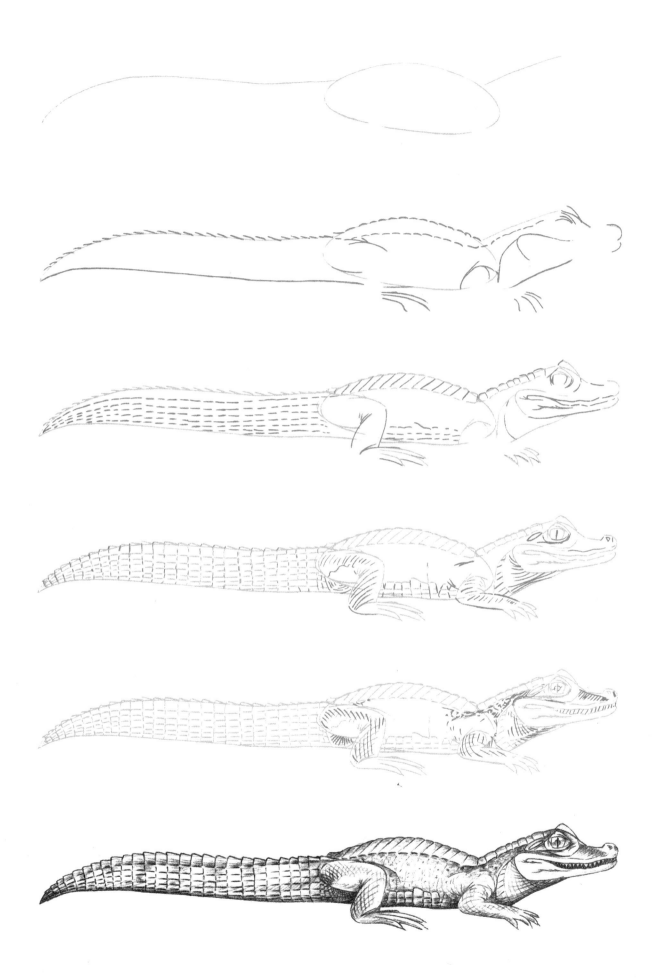

Yacare Caiman

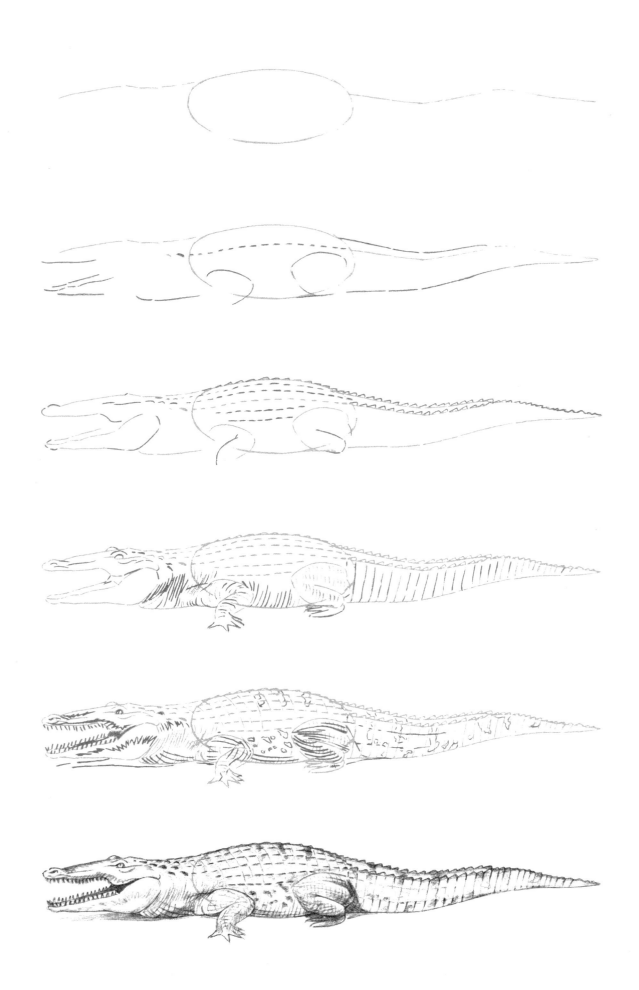

American Crocodile

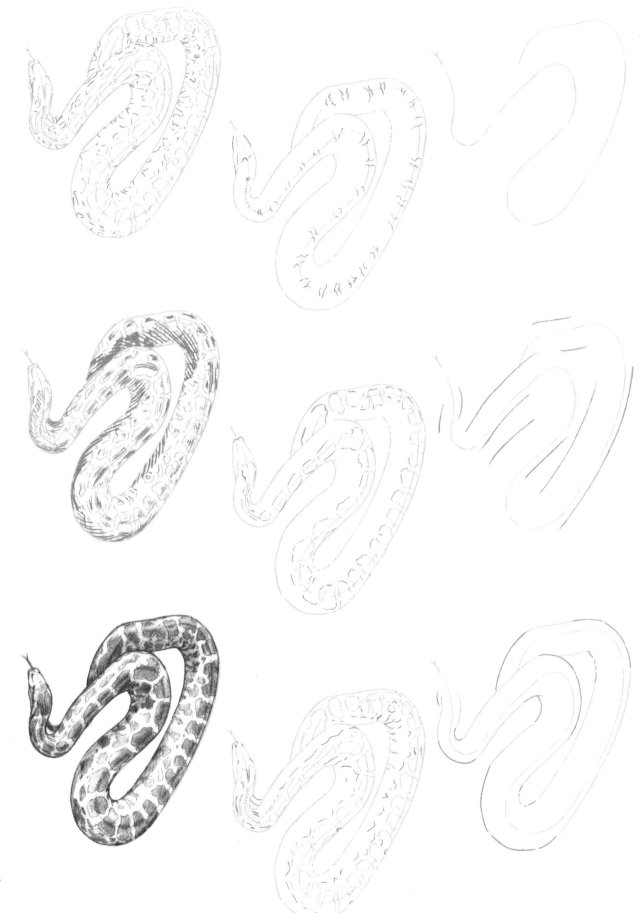

Indian Python

Thin-Spined Porcupine

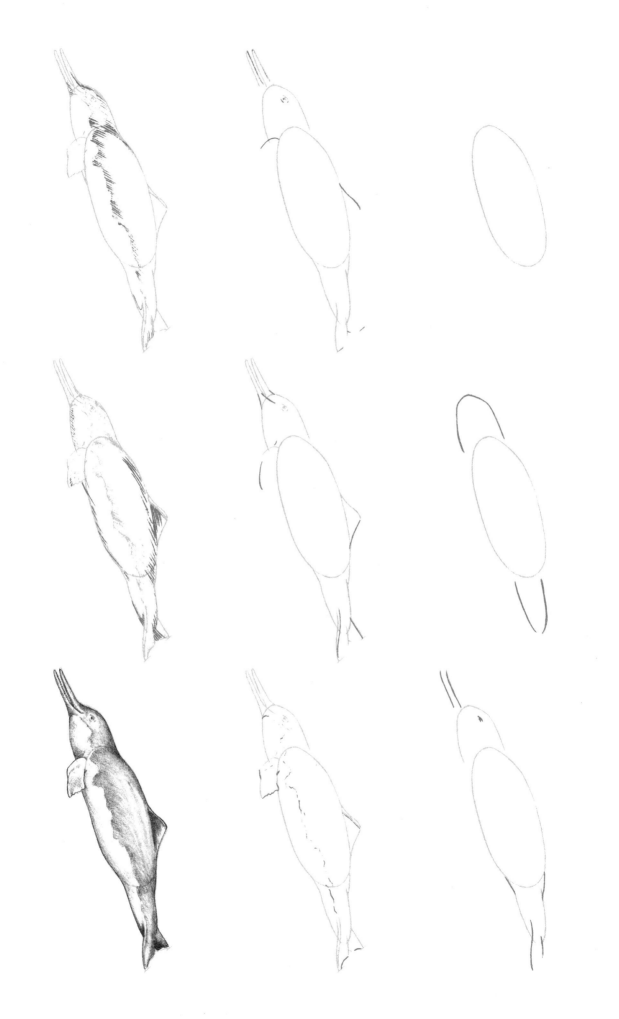

Chinese River Dolphin

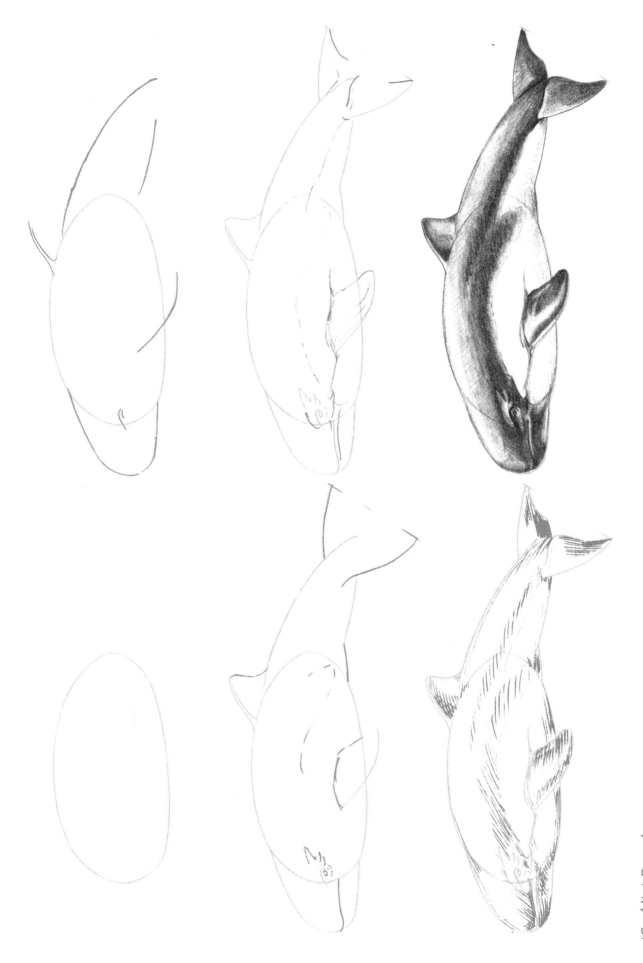

Harbor (Cochito) Porpoise

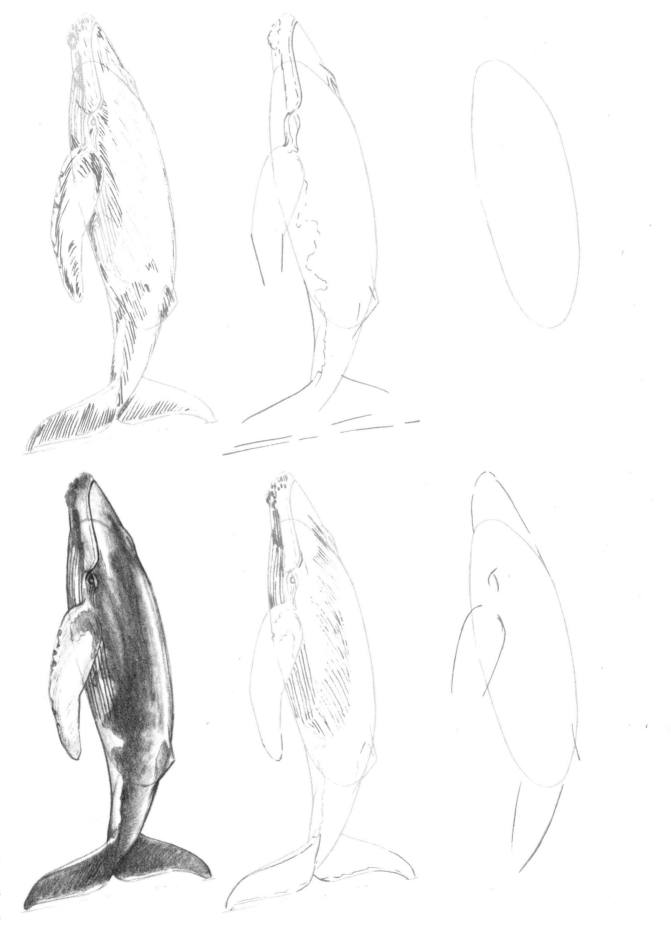

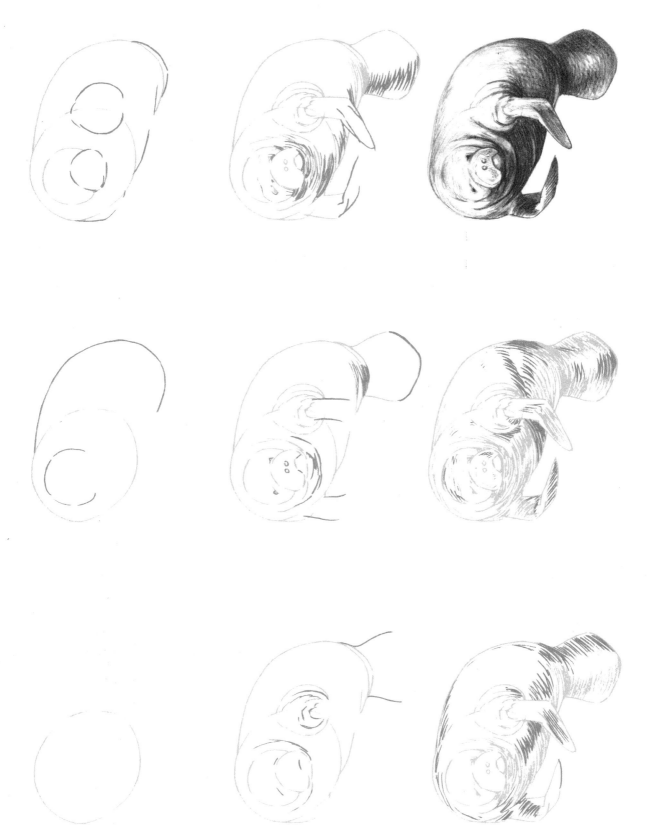

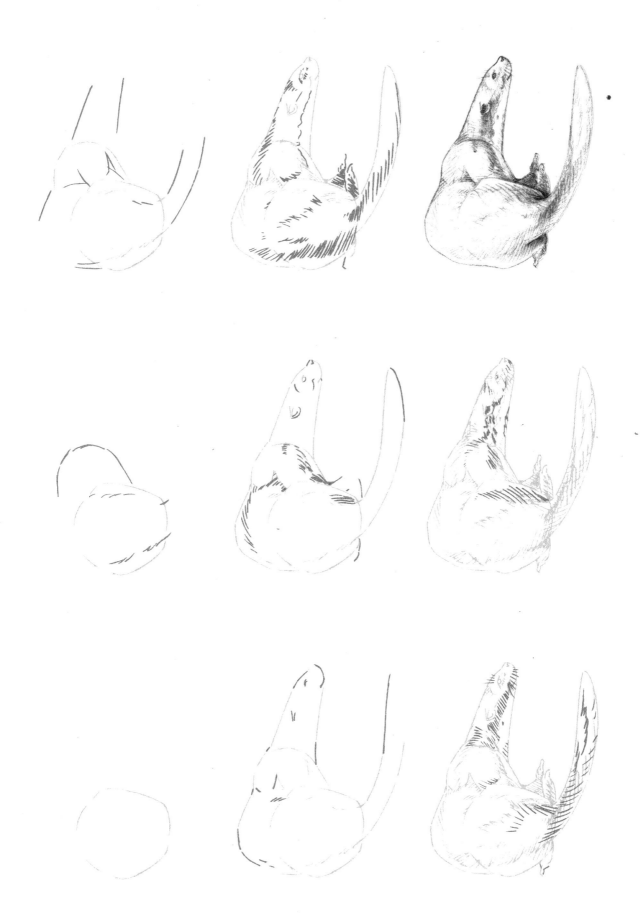

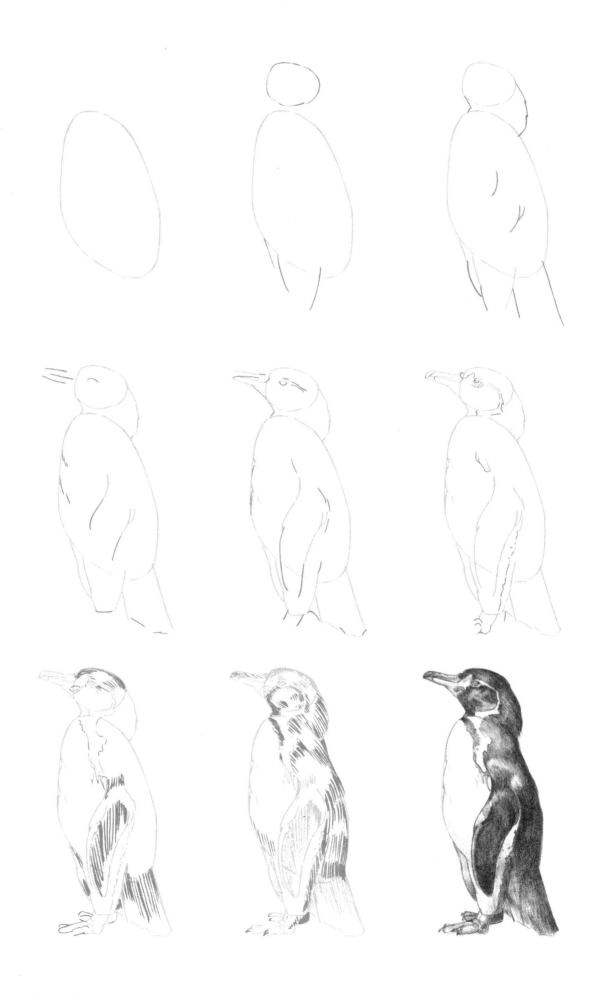

Galápagos Penguin

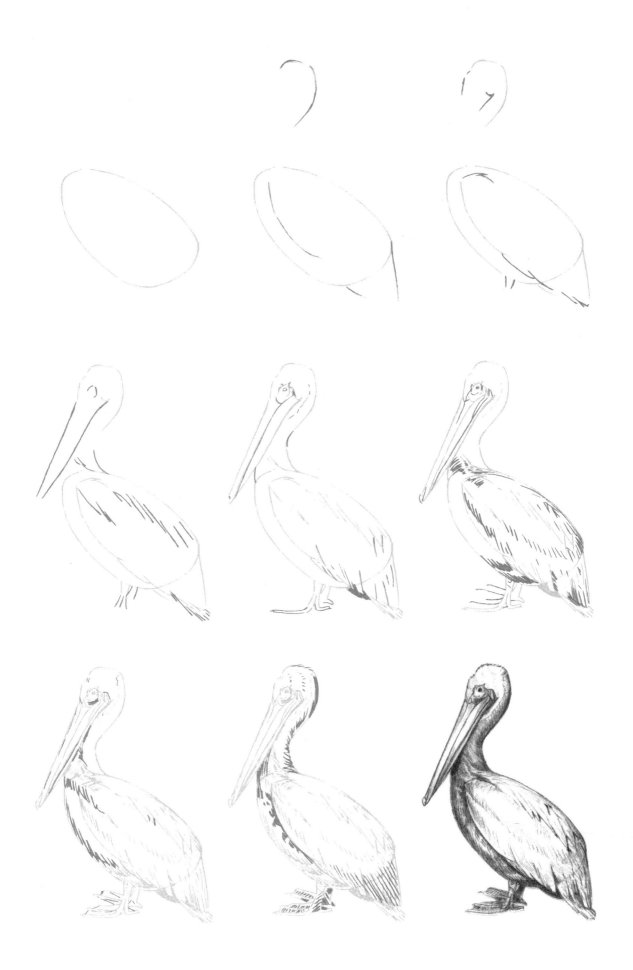

Brown Pelican

Peregrine Falcon

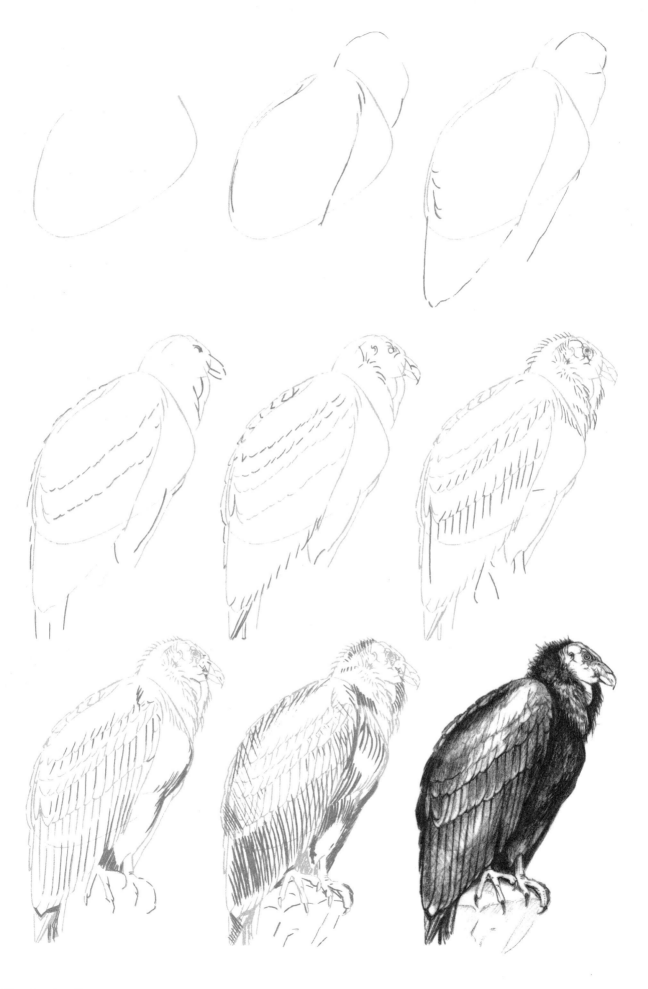

California Condor

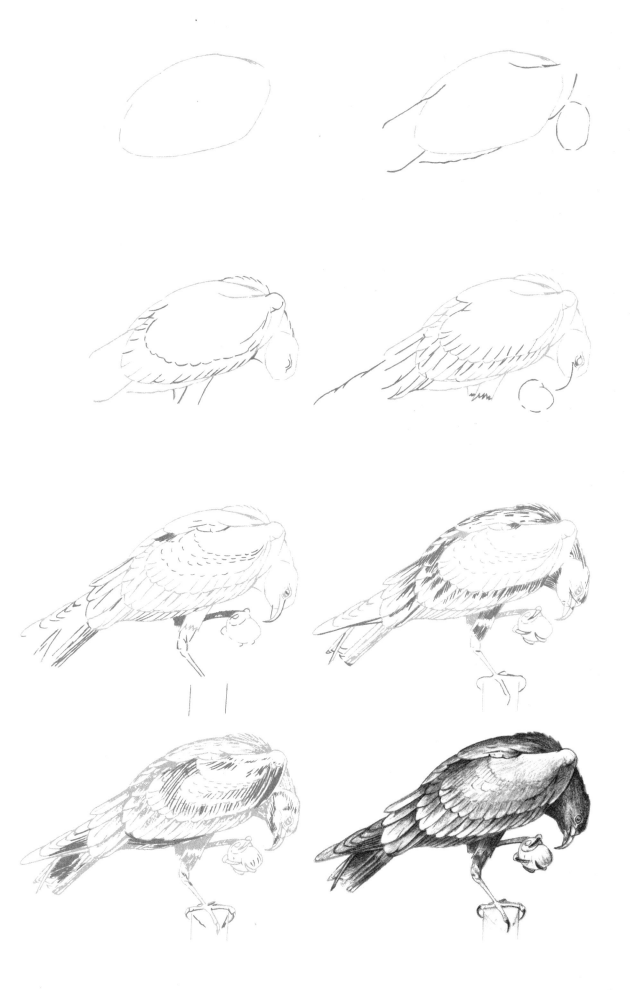

Everglade Snail Kite

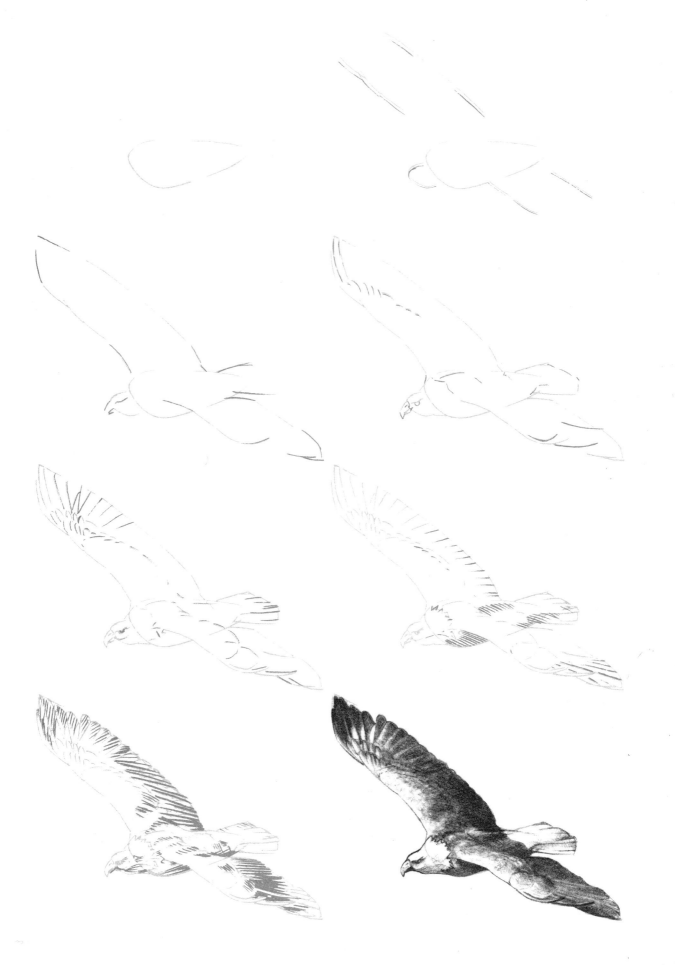

Bald Eagle

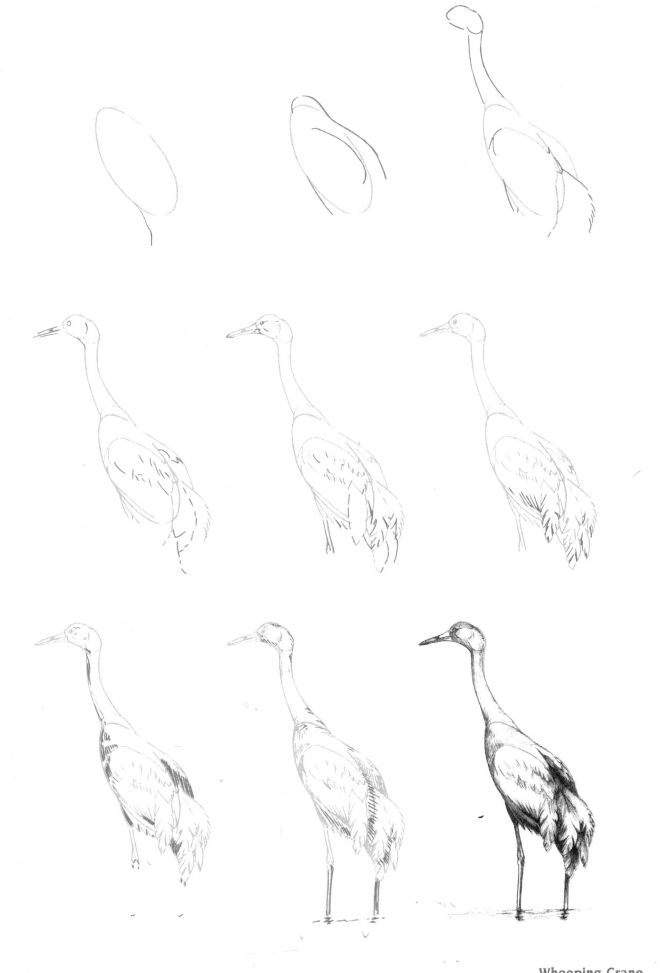

Whooping Crane

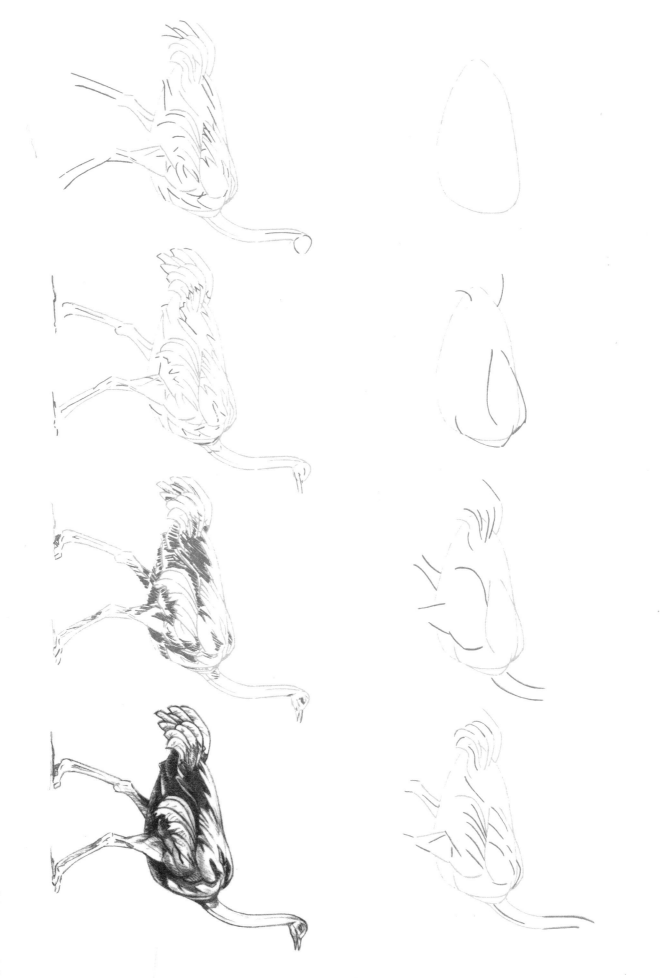

West African Ostrich

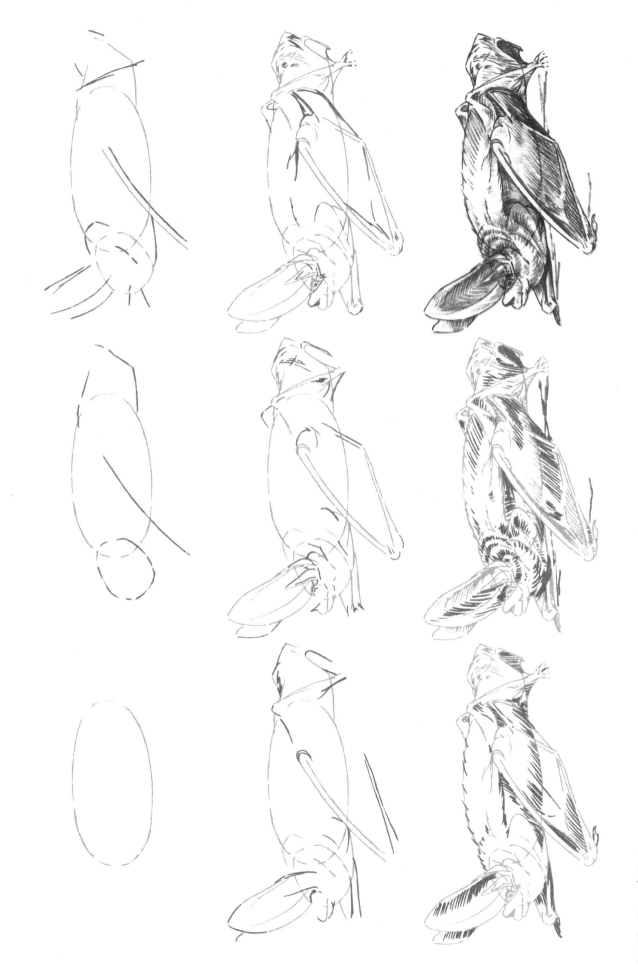

Virginia Big-Eared Bat

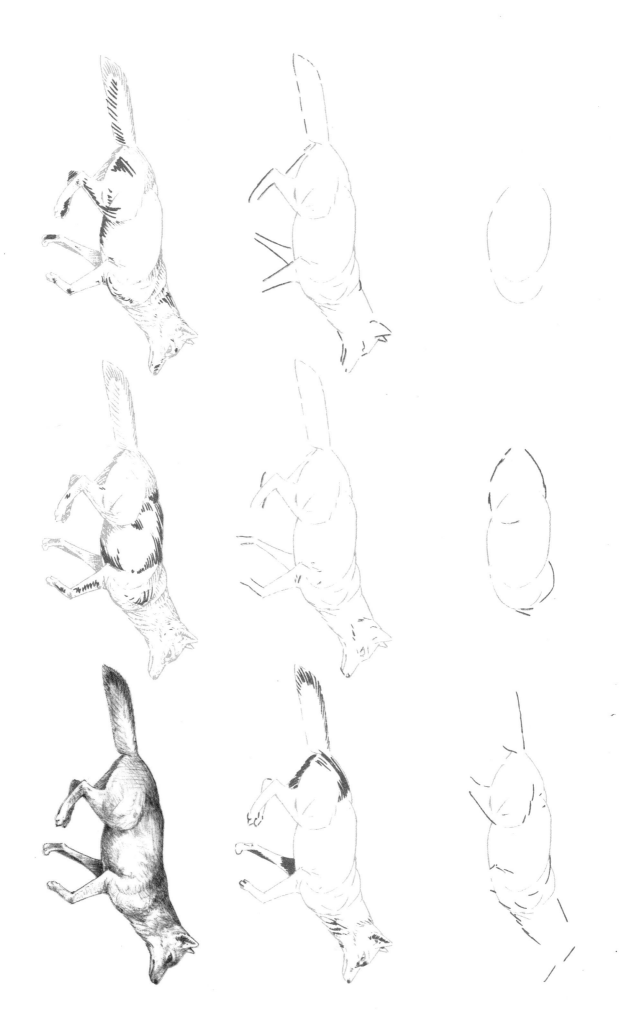

Red Wolf

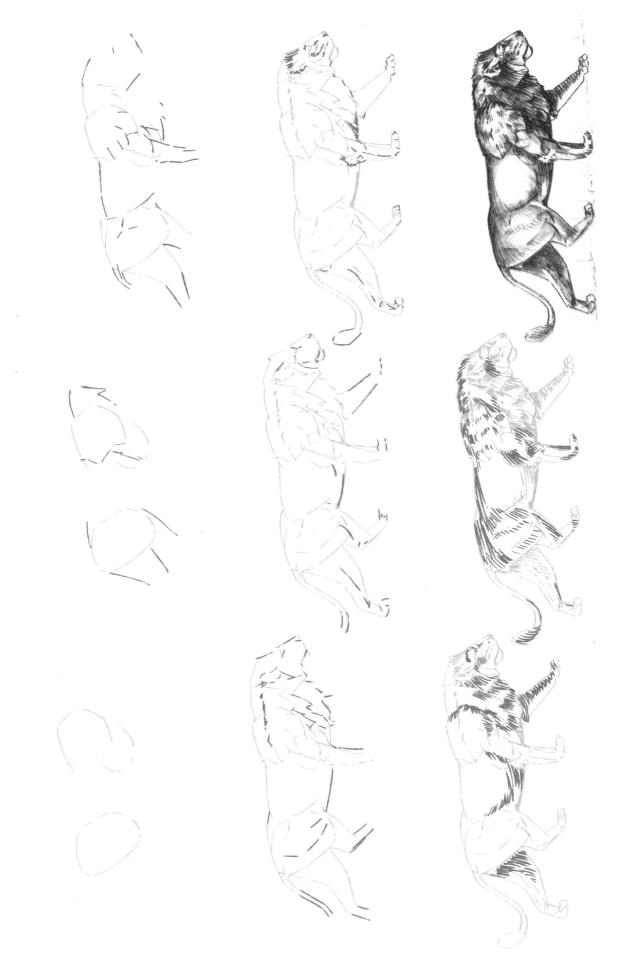

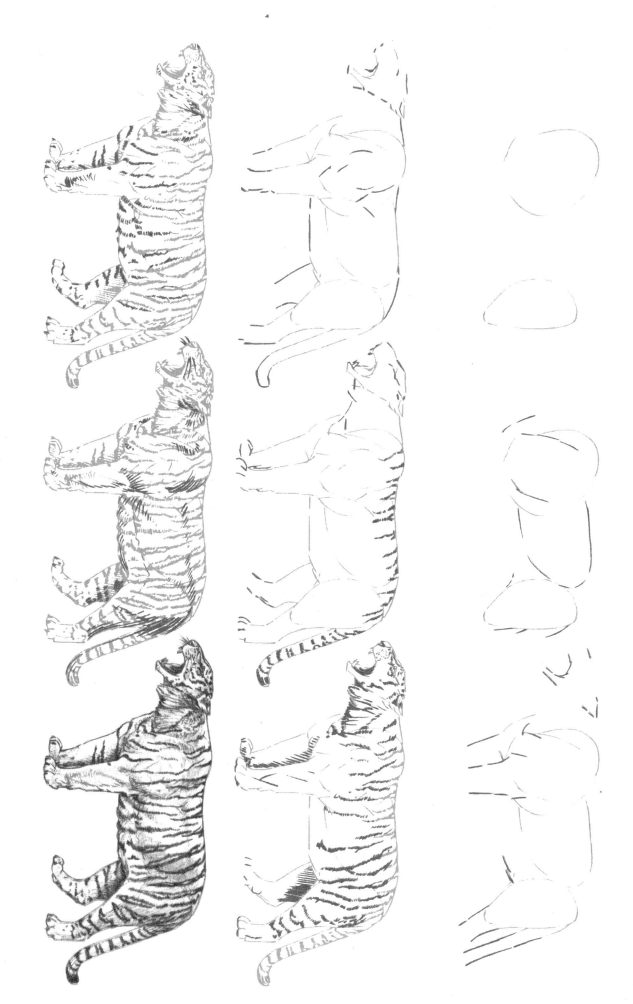

Siberian Tiger

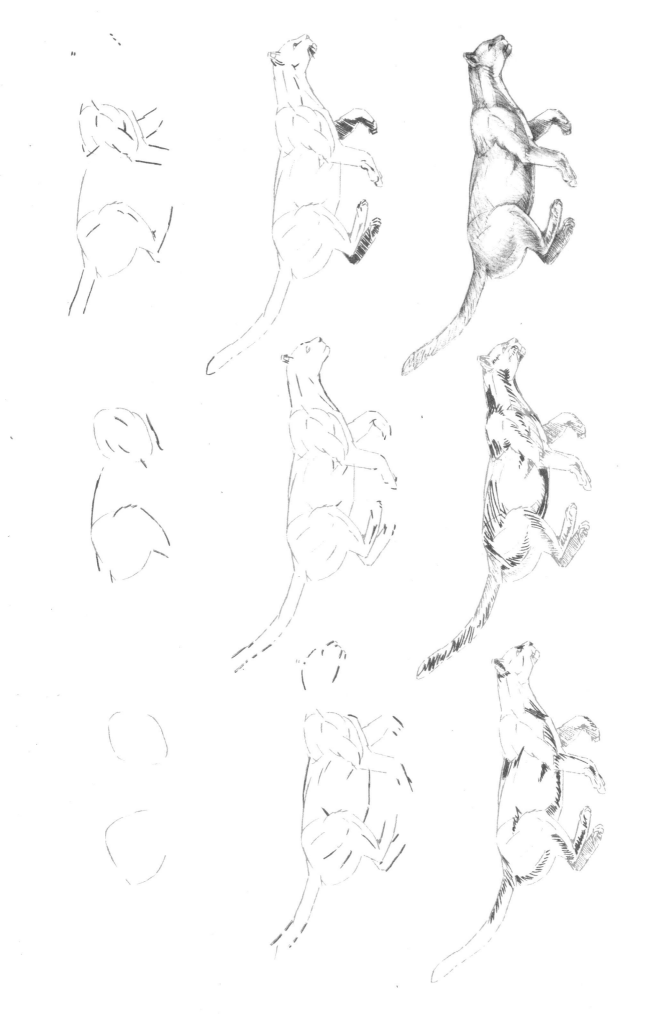

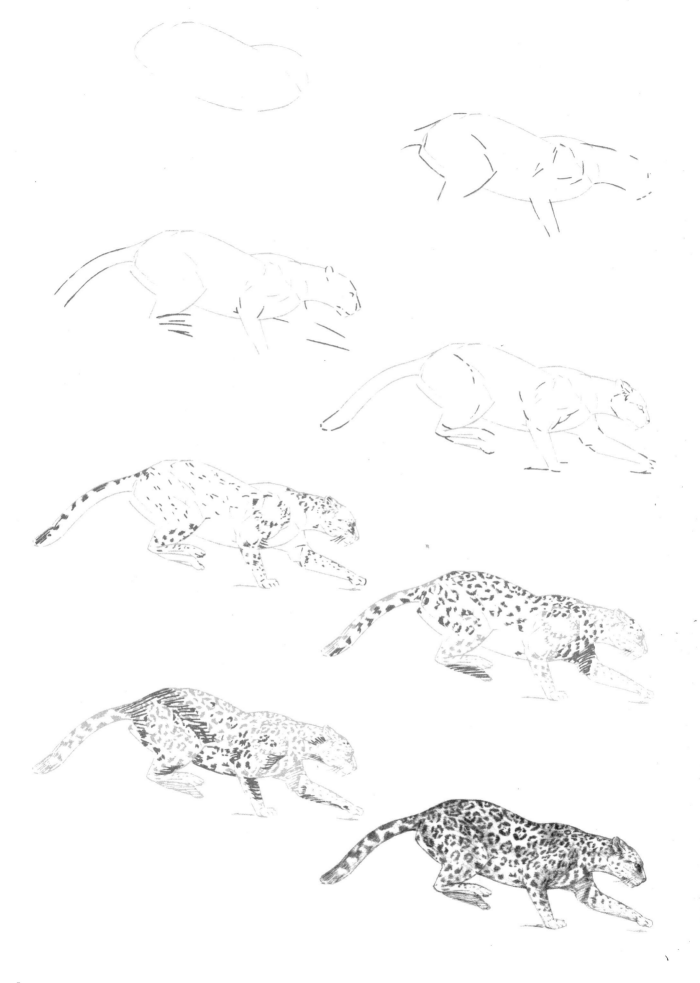

Jaguar

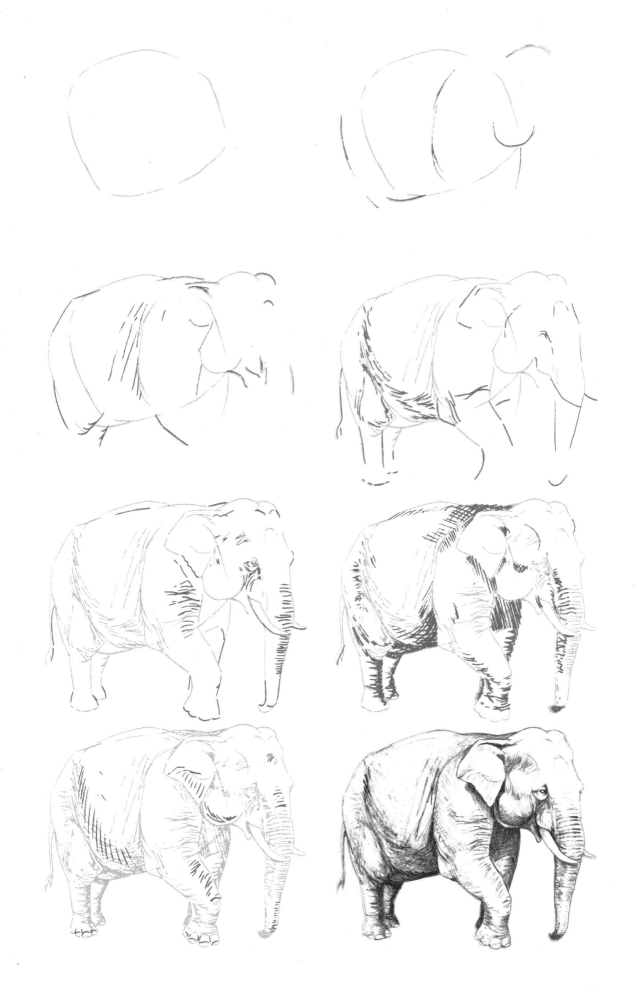

Asian Elephant

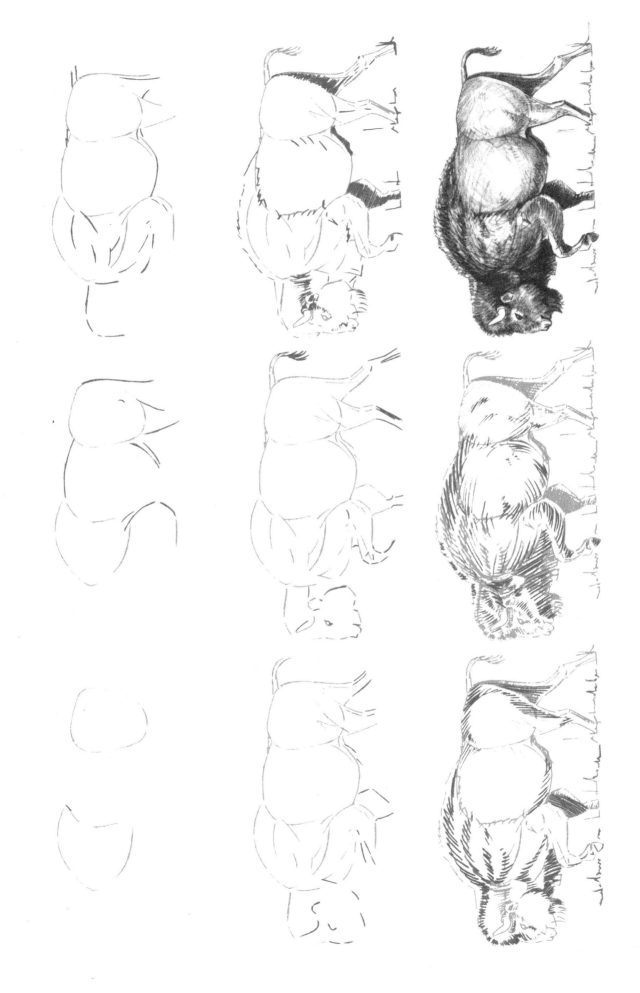

Wood Bison

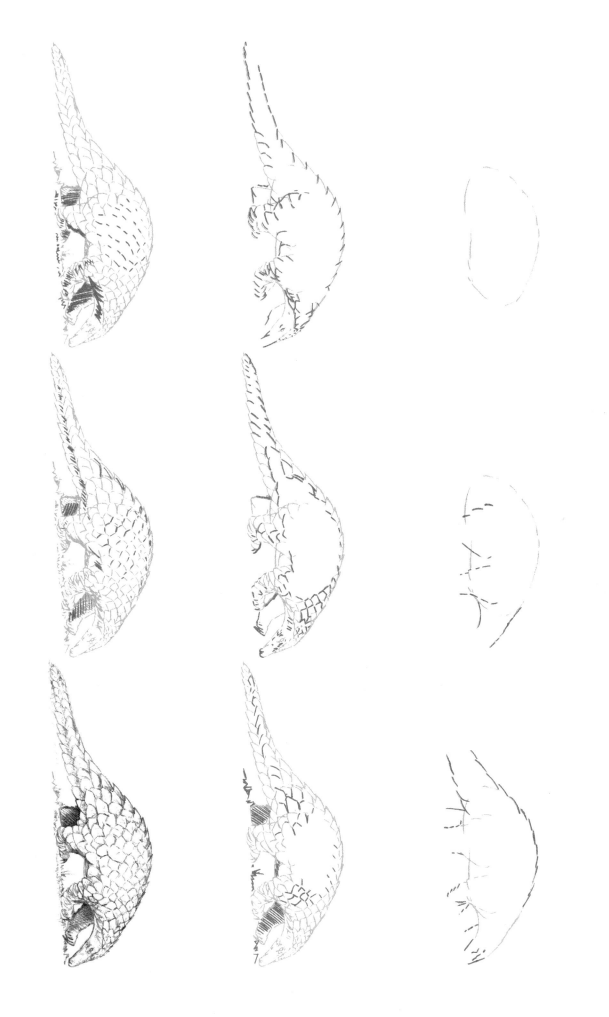

Pangolin

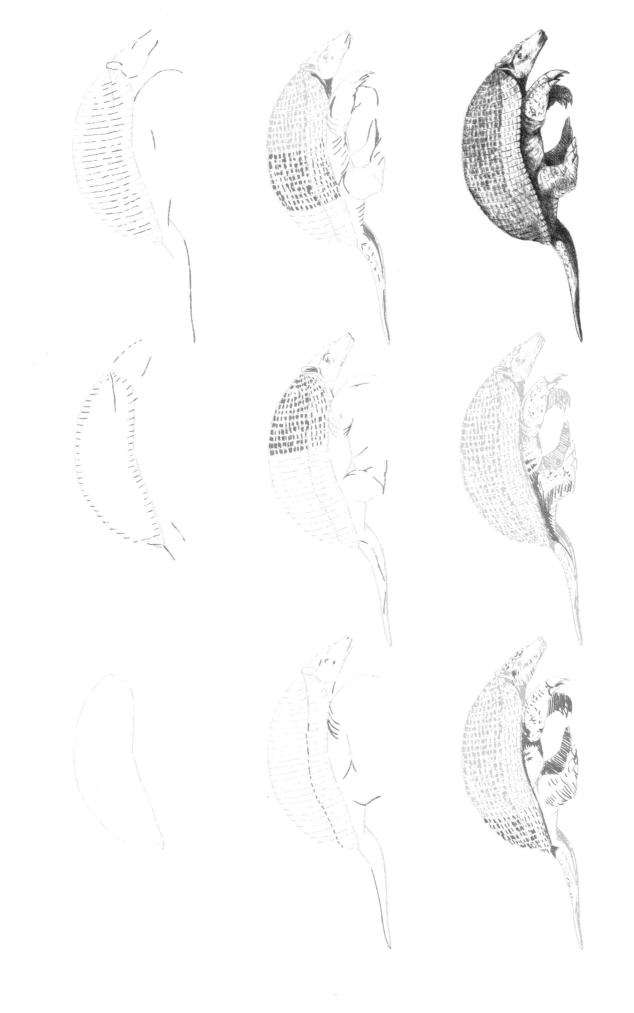

Giant Armadillo

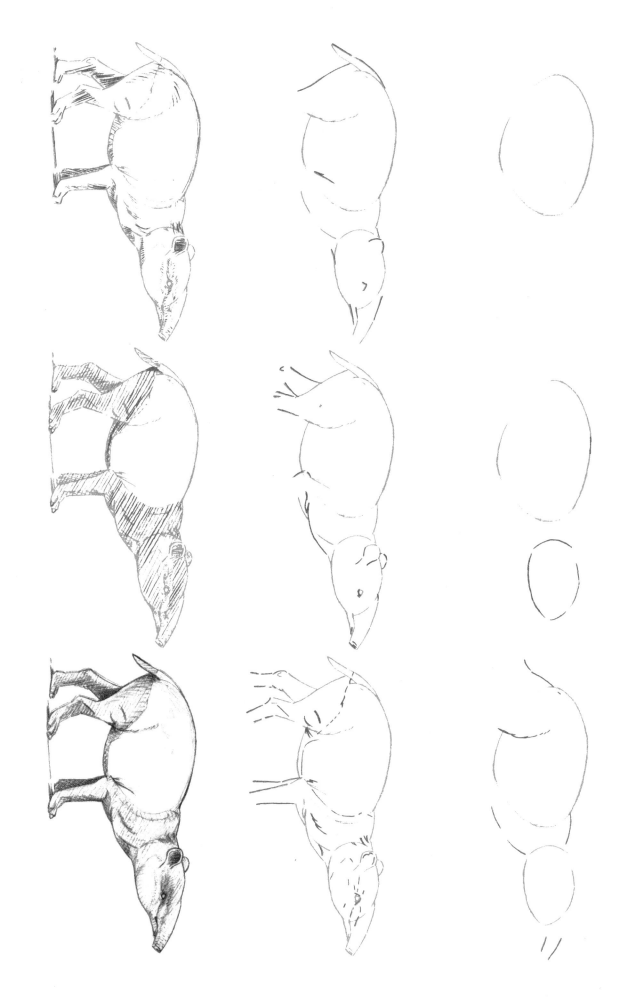

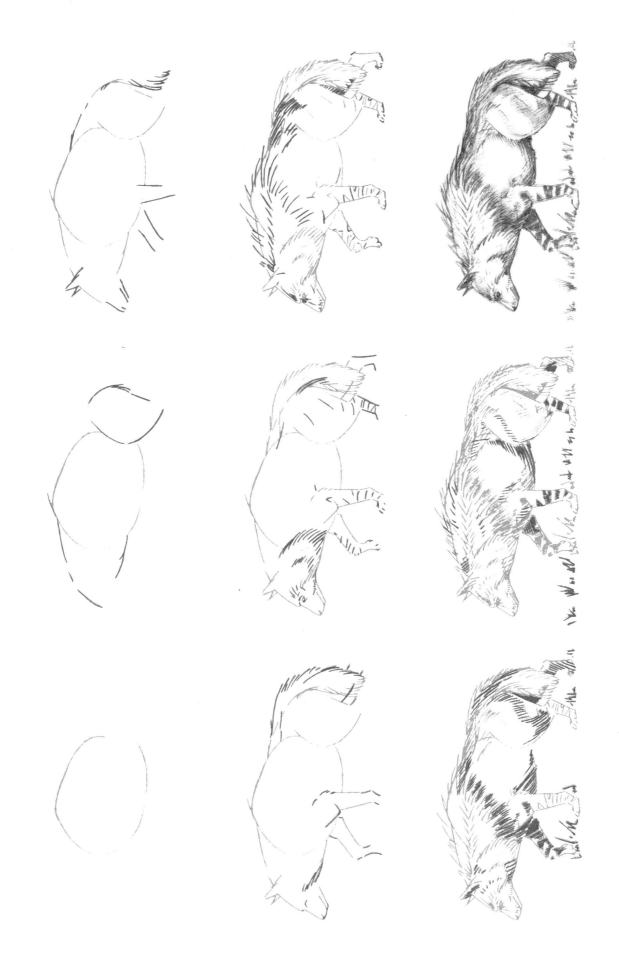

Brown Hyena

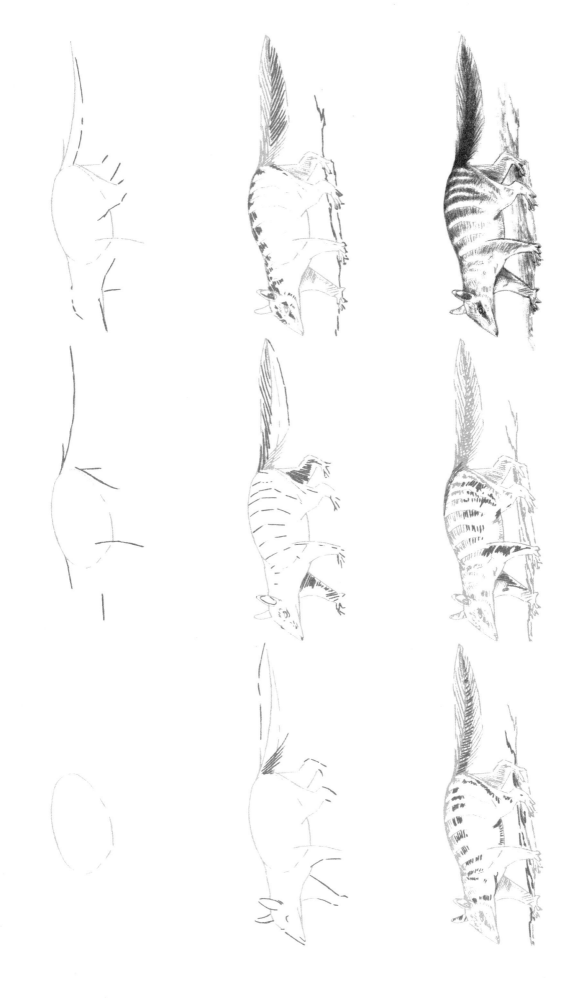

Numbat

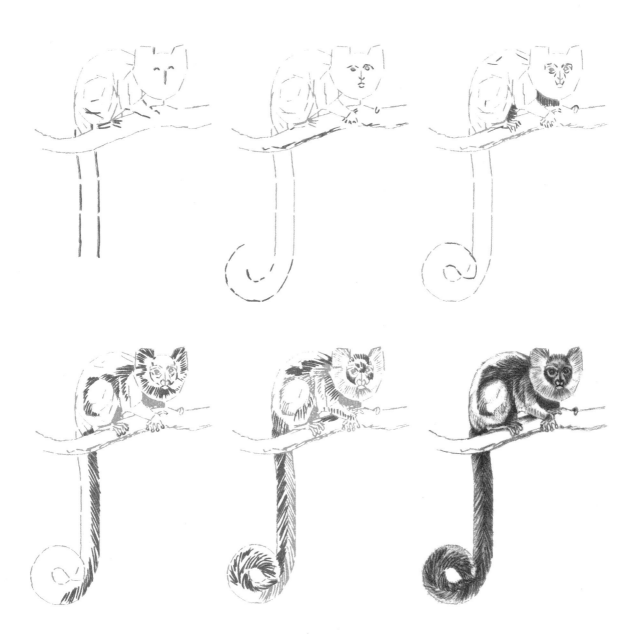

Ruffed Lemur

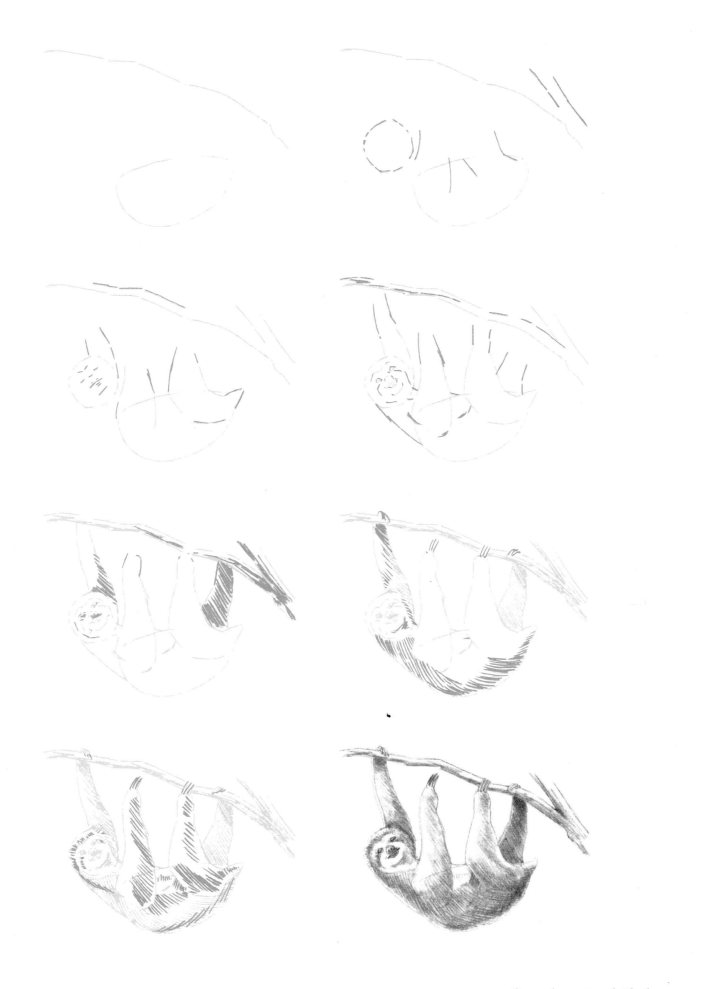

Brazilian Three-Toed Sloth

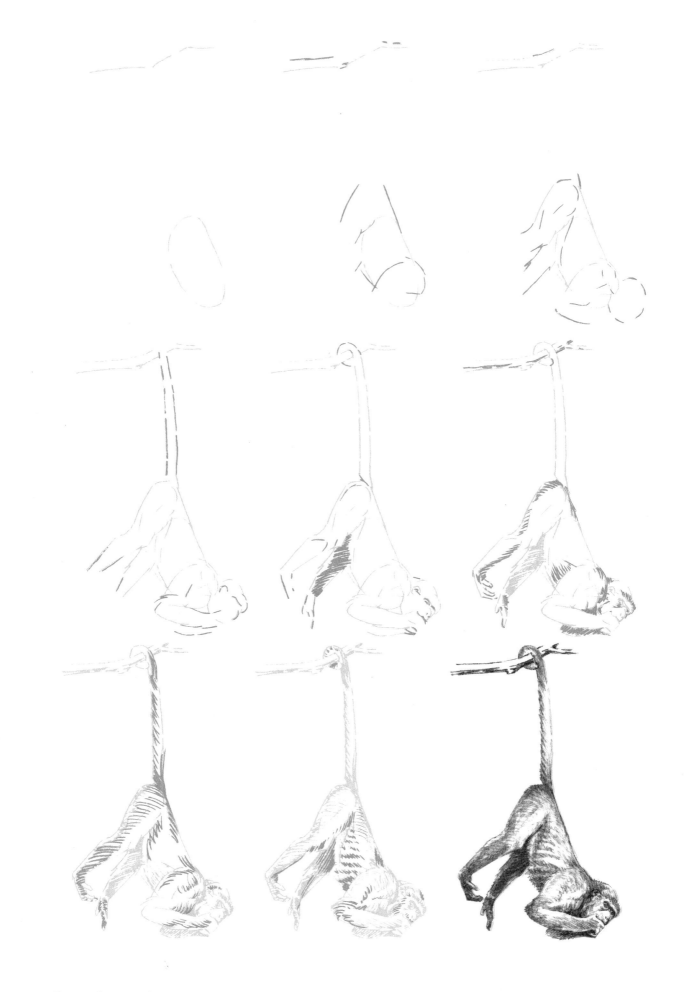

Woolly Spider Monkey

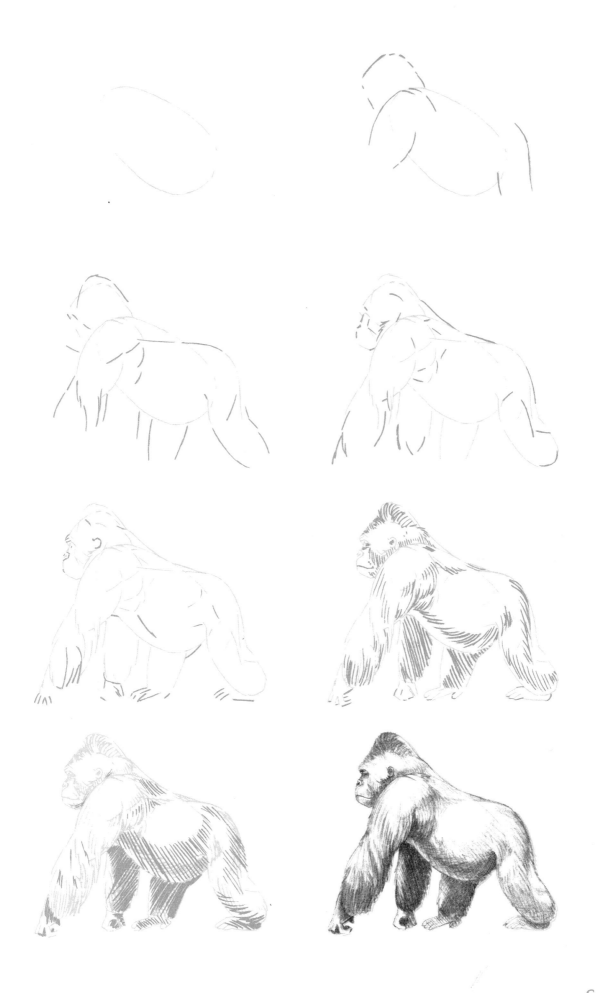

Gorilla

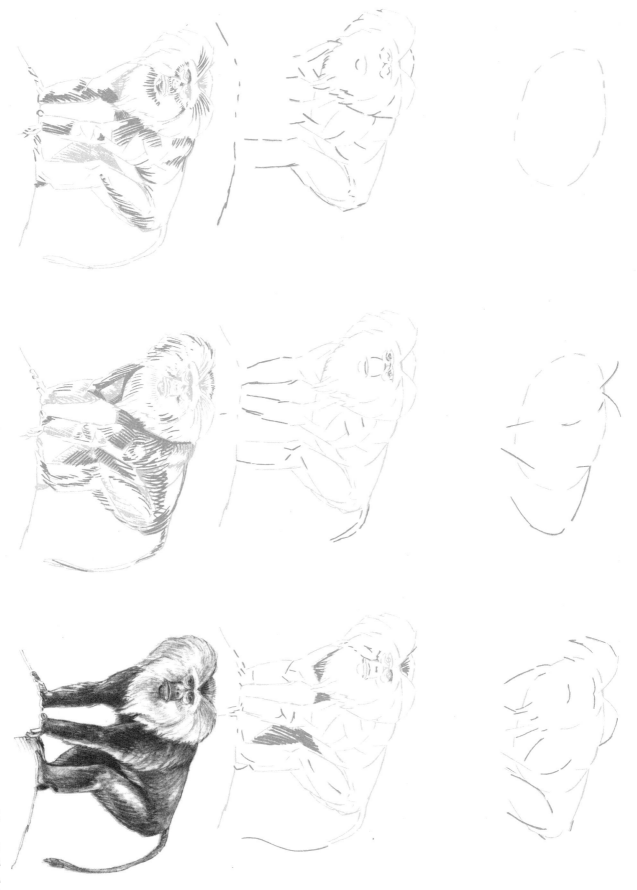

Lion-Tailed Macaque

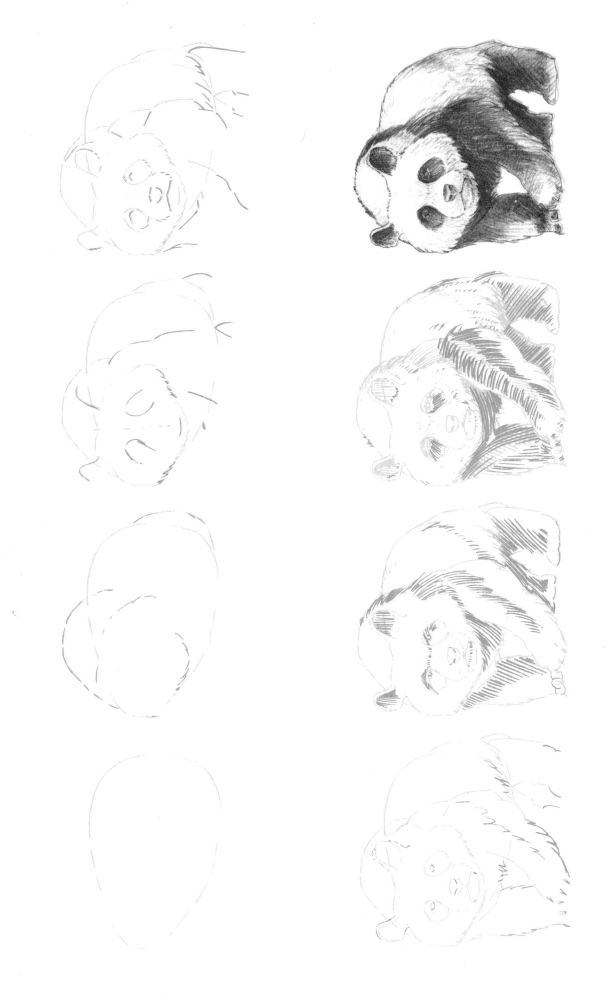

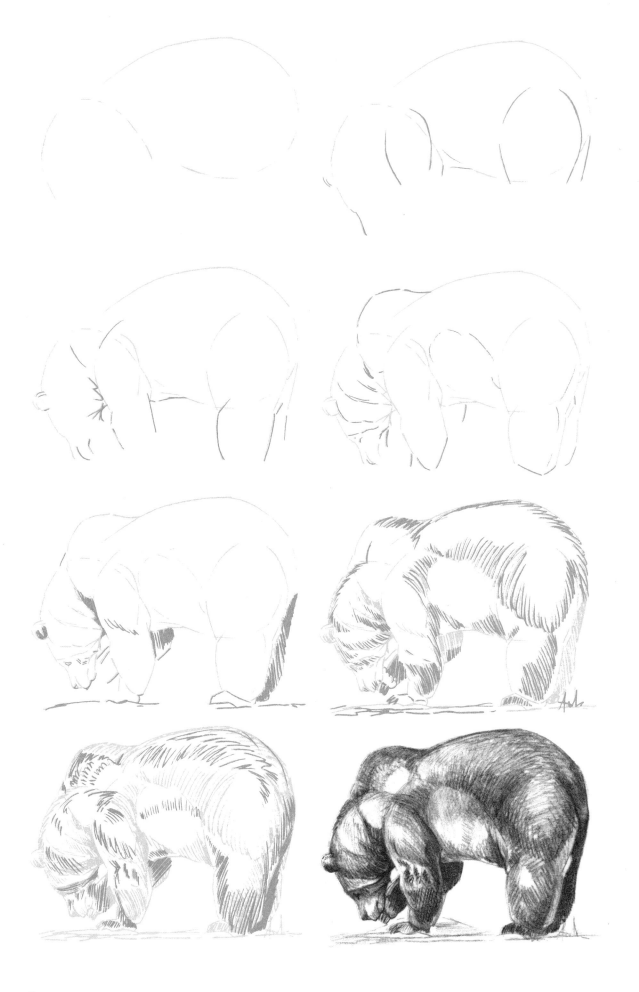

Brown Bear

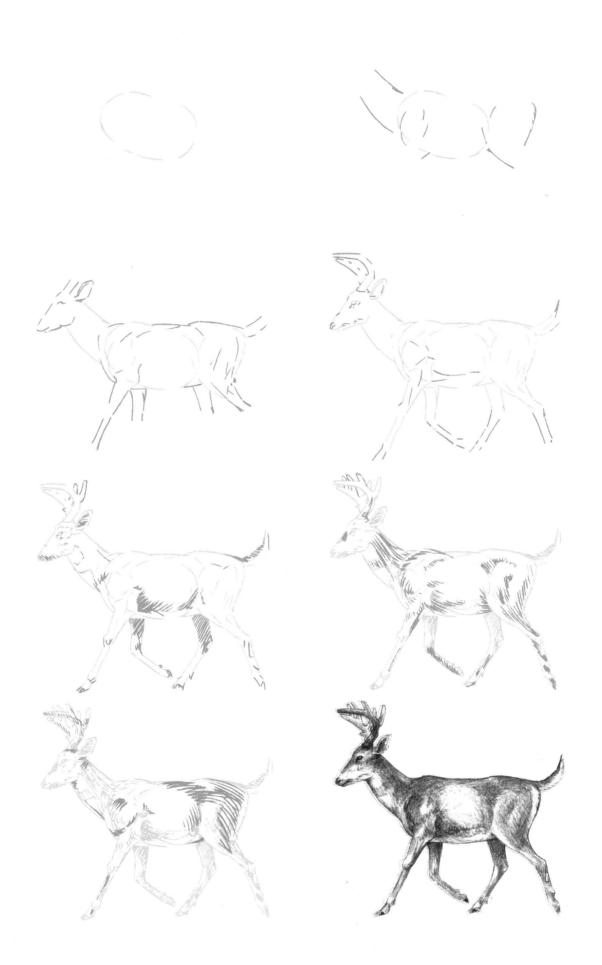

Columbian White-Tailed Deer

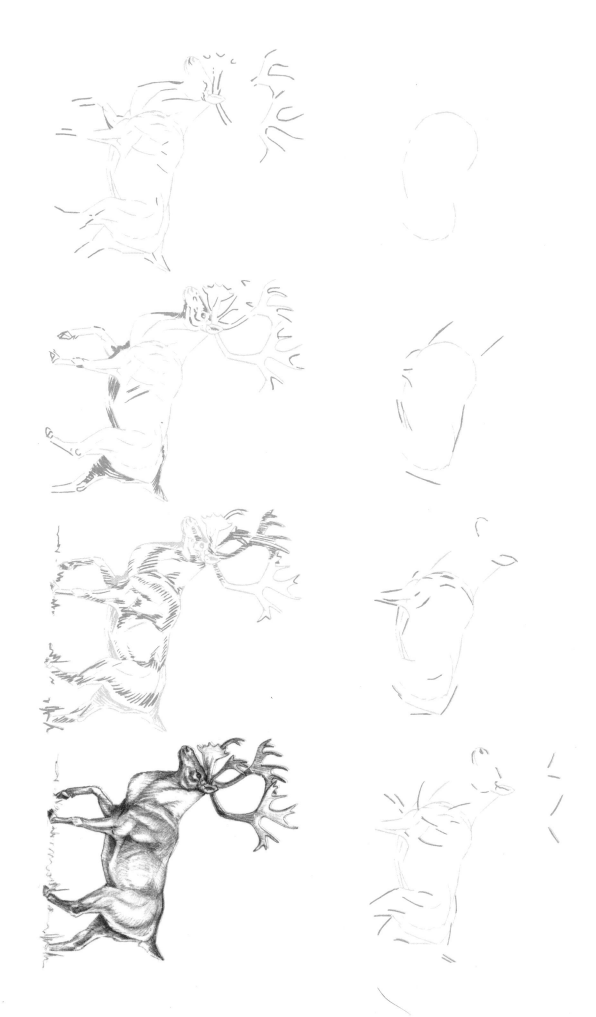

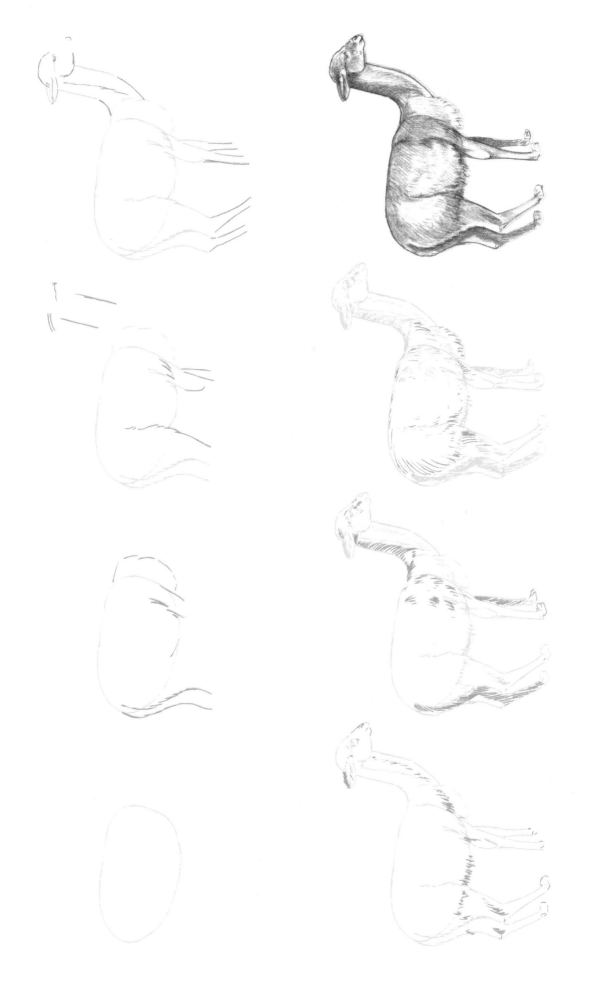

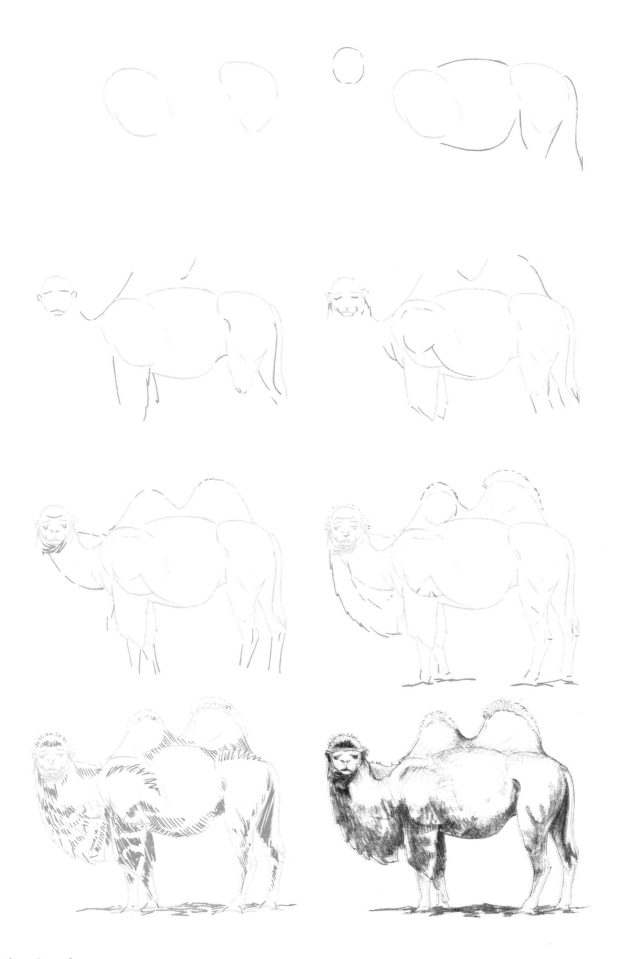

Bactrian Camel

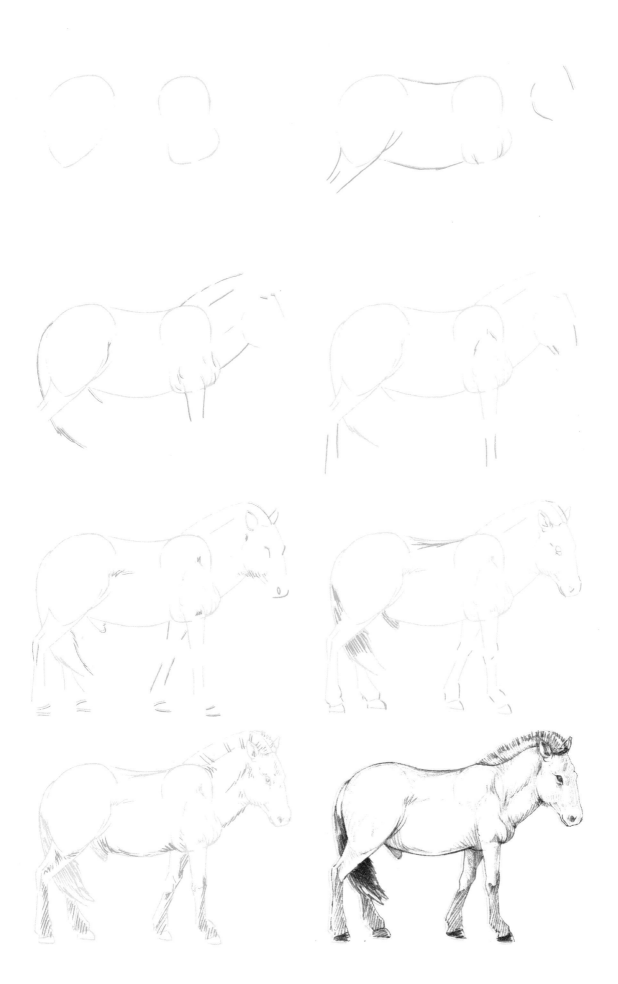

Przhevalsky's Horse

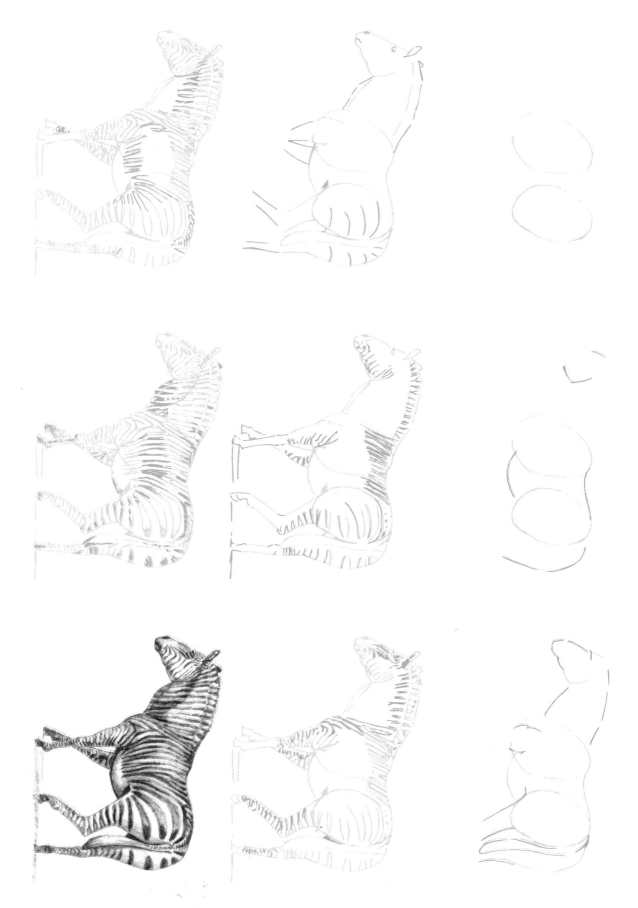

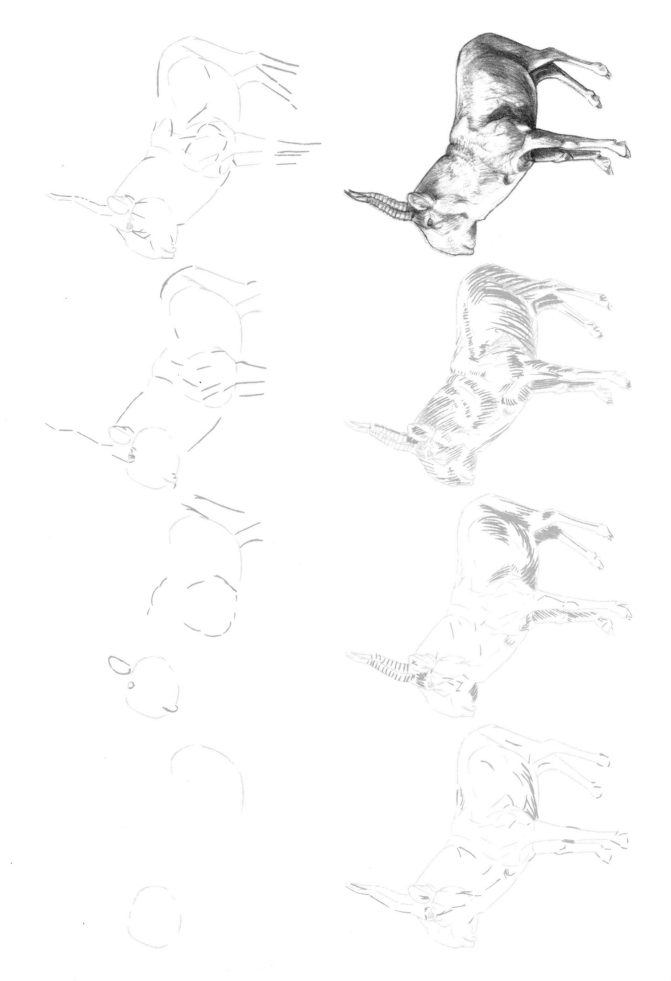

Saiga

Lee J. Ames began his career at the Walt Disney Studios, working on films that included *Fantasia* and *Pinocchio*. He taught at the School of Visual Arts in Manhattan, and at Dowling College on Long Island, New York. An avid worker, Ames directed his own advertising agency, illustrated for several magazines, and illustrated approximately 150 books that range from picture books to postgraduate texts. He resided in Dix Hills, Long Island, with his wife, Jocelyn, until his death in June 2011.

Warren Budd is primarily a natural science artist and book illustrator. He lives on Long Island with his wife Christine and their two children, Bryan and Drew.

DRAW 50 ENDANGERED ANIMALS

Experience All That the Draw 50 Series Has to Offer!

With this proven, step-by-step method, Lee J. Ames has taught millions how to draw everything from amphibians to automobiles. Now it's your turn! Pick up the pencil, get out some paper, and learn how to draw everything under the sun with the Draw 50 series.

Also Available:

- *Draw 50 Aliens*
- *Draw 50 Animals*
- *Draw 50 Animal 'Toons*
- *Draw 50 Athletes*
- *Draw 50 Baby Animals*
- *Draw 50 Beasties*
- *Draw 50 Birds*
- *Draw 50 Boats, Ships, Trucks, and Trains*
- *Draw 50 Cats*
- *Draw 50 Cars, Trucks, and Motorcycles*
- *Draw 50 Creepy Crawlies*
- *Draw 50 Dinosaurs and Other Prehistoric Animals*
- *Draw 50 Dogs*
- *Draw 50 Famous Cartoons*
- *Draw 50 Flowers, Trees, and Other Plants*
- *Draw 50 Horses*
- *Draw 50 Magical Creatures*
- *Draw 50 Monsters*
- *Draw 50 People*
- *Draw 50 Princesses*
- *Draw 50 Sharks, Whales, and Other Sea Creatures*
- *Draw 50 Vehicles*
- *Draw the Draw 50 Way*